THIS WORKBOOK BELONGS TO:

POTTER STYLE

Design by MELISSA CHANG
Cover art contributed by CHRISTOPHER HART
Copyright © 2009 by Potter Style,
a division of Random House, Inc.
Published in the United States by Potter Style,
an imprint of the Crown Publishing Group,
a division of Random House, Inc., New York.

Artwork and text from the book
*Manga for the Beginner: Everything You Need to Start
Drawing Right Away!*
by Christopher Hart, copyright © 2008 by Star Fire, LLC
(New York: Watson-Guptill Publications).
www.clarksonpotter.com
ISBN 978-0-307-46270-1
Printed in China

THE MANGA ARTIST'S WORKBOOK

GET STARTED CREATING YOUR OWN CHARACTERS!

This workbook contains a series of step-by-step lessons to help you master the essential elements of drawing manga characters: proportion, expressions, costume, and perspective, to name a few. Creating a successful drawing requires combining all of these elements, which can be challenging if you don't have the proper instructions to help you along. This workbook will help you focus on perfecting one element of character drawing at a time.

To get started, keep the journal spread flat; the instructions are printed on the top page, and space for drawing is below. You'll be asked to copy finished drawings, complete partially drawn examples, and trace some of the more advanced aspects of the face and figure (tracing paper is included). Copying and tracing is actually the best way to learn what to look for in a good drawing. Many pros started this way.

The various sections in this workbook will help you to

• master the fundamental proportions of the manga body and facial features
• add details to manga eyes so they sparkle and shine
• develop hairstyles and costumes that make each character unique
• create expressive and dynamic characters

The key to mastering the basics is taking your time with each exercise. After some practice, they will become second nature to you, and you'll be able to start putting an individual stamp on your manga characters. It will be fun and rewarding to see how much your artistry has improved by the time you fill up this book!

THE MANGA HEAD

TEEN GIRL

FRONT VIEW

The typical manga teenage girl has a rounded head that tapers to a pointed chin. Her eyes are huge and placed low on the face for a youthful appearance. • Everyone starts with the front view, because it seems like the easiest pose to draw. Well, let me let you in on a little secret: the front view is actually one of the hardest! In the front view, you have to draw the entire outline of the head symmetrically, lining up the eyes and ears perfectly, foreshortening the nose, and designing a hairstyle that covers the entire head. But if you break down the process with guidelines, it becomes much easier. These guidelines show you where to place the features.

FIG 1 Guidelines help you place the eyes, nose, and mouth.

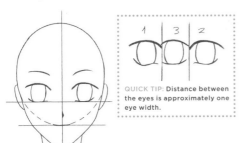

QUICK TIP: Distance between the eyes is approximately one eye width.

FIG 2 Start filling in the details. Note that hair never lies flat; it always adds size to the head.

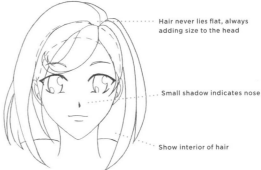

Hair never lies flat, always adding size to the head

Small shadow indicates nose

Show interior of hair

FIG 3 Here's the fun part. All your hard work is in place, and you can start to fill in the eyes, strands of hair, flowers, and any other details you'd like to add to your character.

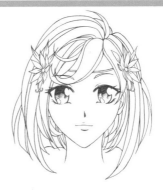

TRACE THIS!

Use this outline as the foundation for your drawing.
Take careful note of where the guidelines are.

Center line divides head evenly in half and indicates nose placement

Eye line falls where jaw and skull meet

Mouth guideline falls at bottom of skull circle

QUICK TIP

The mouth falls about halfway between the eye line and the bottom of the chin. Use this to do a quick spot check on any drawing to ensure the positioning is correct.

THE MANGA HEAD

TEEN GIRL

PROFILE The profile, or side view, is easy to draw—except for one part. The sticking point is the mouth/chin area underneath the nose. If an artist is going to get a bit off track, that's often where it happens. Remember that, on female characters, the lips always protrude past the chin.

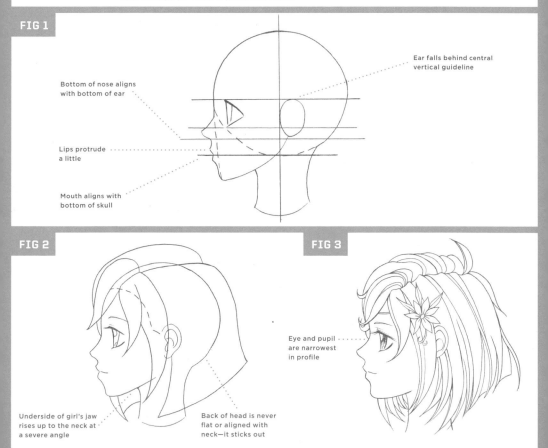

FIG 1

Ear falls behind central vertical guideline

Bottom of nose aligns with bottom of ear

Lips protrude a little

Mouth aligns with bottom of skull

FIG 2

Underside of girl's jaw rises up to the neck at a severe angle

Back of head is never flat or aligned with neck—it sticks out

FIG 3

Eye and pupil are narrowest in profile

Use this outline as the beginning of your own drawing.
Add your own guidelines and features.

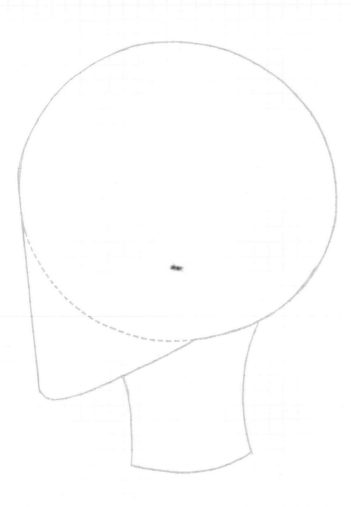

THE MANGA HEAD

TEEN GIRL

THREE-QUARTERS VIEW

The three-quarters view is halfway between the front view and the profile. It is generally considered the most pleasing angle in which to draw a character. The key to making this pose work is the center line. With the exception of the front view, the center line curves around the face; it is never a straight line. The bridge of the nose follows the center line, cutting off part of the far eye. Remember that and you'll be able to draw this angle easily.

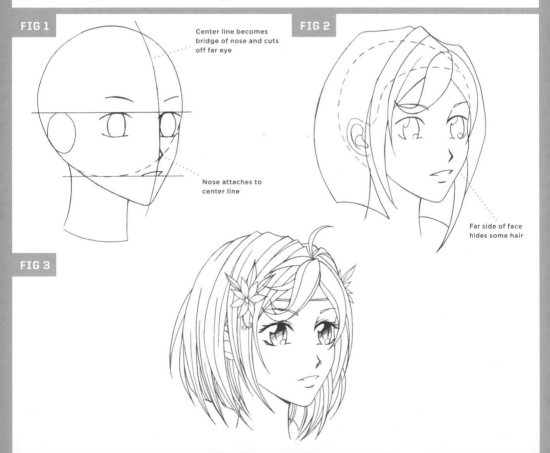

FIG 1

Center line becomes bridge of nose and cuts off far eye

Nose attaches to center line

FIG 2

Far side of face hides some hair

FIG 3

YOUR TURN!

Use this outline as the beginning of your own drawing.
Add your own guidelines and features.

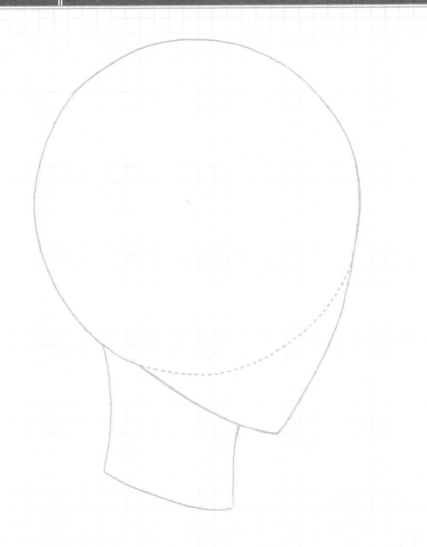

THE MANGA HEAD

"UP" ANGLE

The key to drawing this pose begins with the fundamentals—the guidelines. This time, draw three main horizontal guidelines: the eye line, the mouth line, and the chin line. For this pose to work, all of these guidelines must be drawn on a significant downward curve.

FIG 1

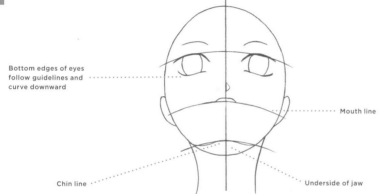

Bottom edges of eyes follow guidelines and curve downward

Mouth line

Chin line

Underside of jaw

FIG 2

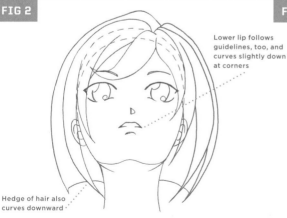

Lower lip follows guidelines, too, and curves slightly down at corners

Hedge of hair also curves downward

FIG 3

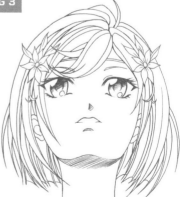

Use this outline as the beginning of your own drawing.
Add your own guidelines and features.

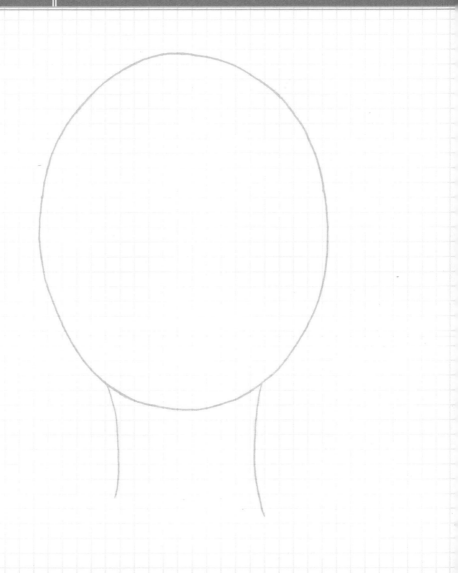

THE MANGA HEAD

"DOWN" ANGLE

Drawing a character looking down calls for a greater use of perspective than does any other angle. It might feel wrong to exaggerate the drawing to such a degree in the first few steps, but remember that from this angle, perspective distorts things. Here, we reverse the angle of the guidelines so that they all curve upward.

FIG 1

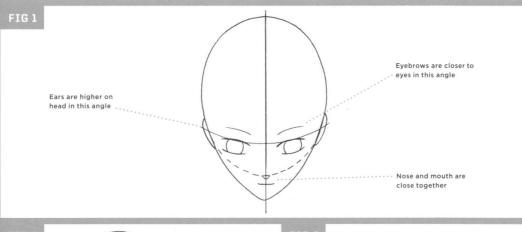

Ears are higher on head in this angle

Eyebrows are closer to eyes in this angle

Nose and mouth are close together

FIG 2

More top of head shows

FIG 3

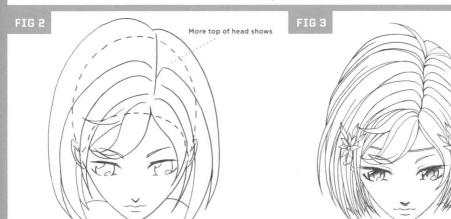

Use this outline as the beginning of your own drawing.
Add your own guidelines and features.

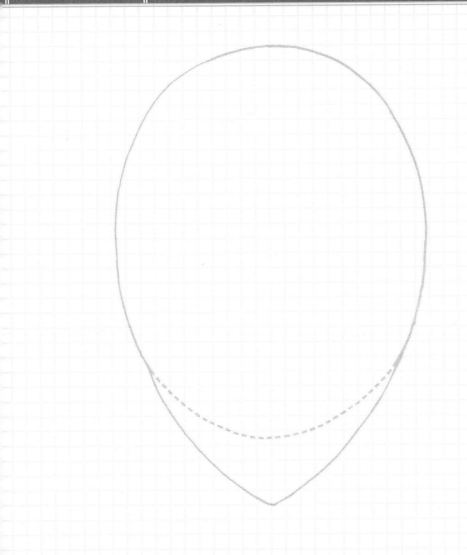

THE MANGA HEAD

TEEN BOY

FRONT VIEW The outline of the boy's head is similar to that of the girl's, but the jaw is more angular and the chin is more square. In addition, the overall head shape is a little bit more oblong, less circular. The neck is wider and sometimes has an indication of an Adam's apple. • Note that the eye line in this front view is the top eye line, whereas the eye line in the Teen Girl front view is the bottom eye line. Using either guideline works; it's just a matter of personal taste.

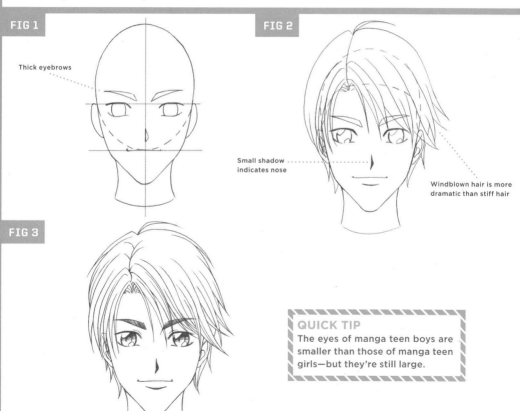

FIG 1

Thick eyebrows

FIG 2

Small shadow indicates nose

Windblown hair is more dramatic than stiff hair

FIG 3

QUICK TIP
The eyes of manga teen boys are smaller than those of manga teen girls—but they're still large.

TRACE THIS!

Use this outline as the foundation for your drawing.
Take careful note of where the guidelines are.

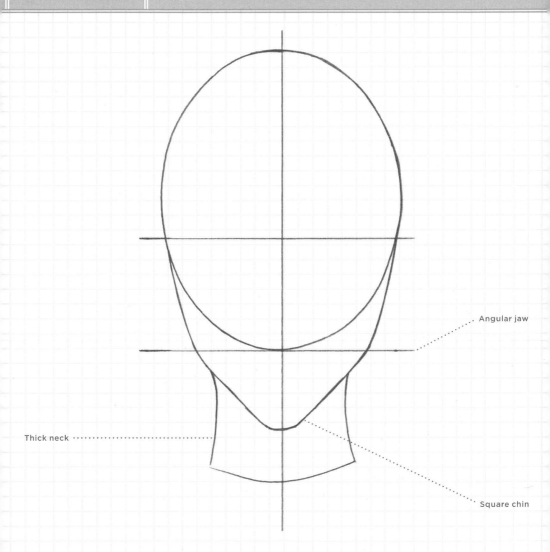

Angular jaw

Thick neck

Square chin

THE MANGA HEAD

TEEN BOY

PROFILE

As with the female profile, the angle of the front plane of the face tilts slightly inward from the forehead to the chin in the male profile. And note the hard jawline; it's not soft like on the teen girl.

FIG 1

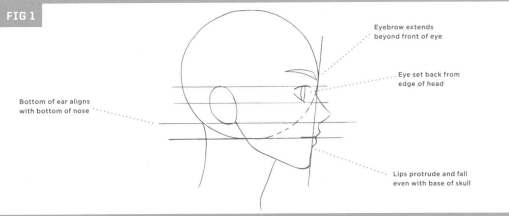

Eyebrow extends beyond front of eye

Eye set back from edge of head

Bottom of ear aligns with bottom of nose

Lips protrude and fall even with base of skull

FIG 2

FIG 3

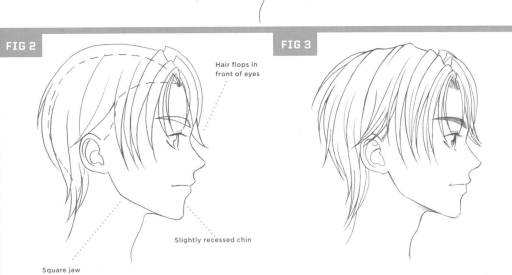

Hair flops in front of eyes

Slightly recessed chin

Square jaw

Use this outline as the beginning of your own drawing.
Add your own guidelines and features.

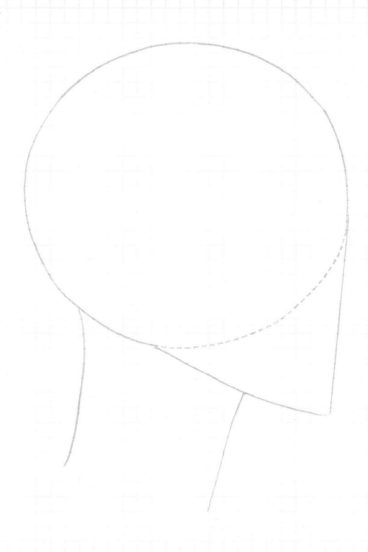

TEEN BOY

THREE-QUARTERS VIEW

As a young boy matures, his face becomes sleeker. You can see this in the far side of his face.

FIG 1

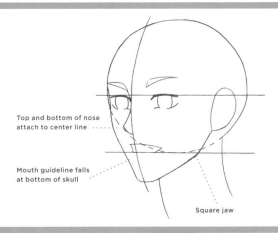

Top and bottom of nose attach to center line

Mouth guideline falls at bottom of skull

Square jaw

FIG 2

Leaving the lips open and the mouth empty (with no individual teeth indicated) creates the look of bright teeth.

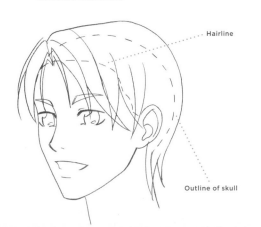

Hairline

Outline of skull

FIG 3

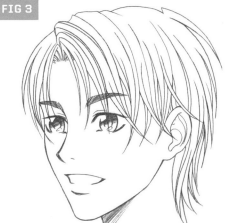

YOUR TURN!

Use this outline as the beginning of your own drawing.
Add your own guidelines and features.

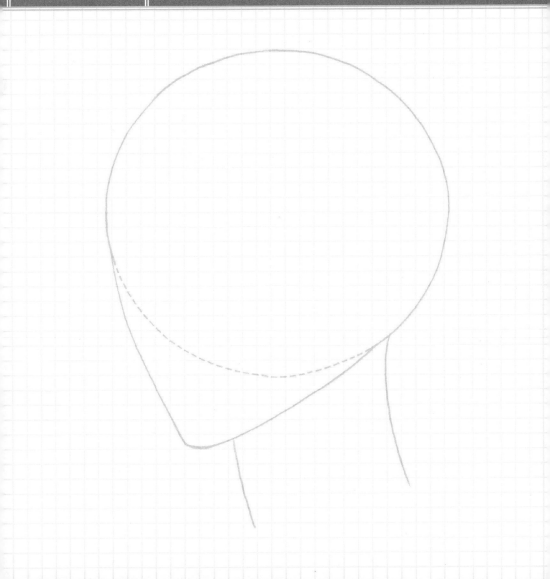

THE MANGA HEAD

"UP" ANGLE The "up-looking" angle gives teenage boys a courageous look. To exaggerate this angle, curve the edges of the horizontal guidelines even more steeply downward.

FIG 1

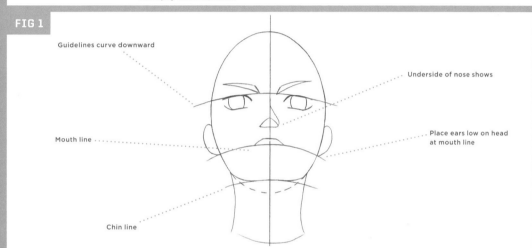

Guidelines curve downward

Underside of nose shows

Mouth line

Place ears low on head at mouth line

Chin line

FIG 2

Less top of head shows

FIG 3

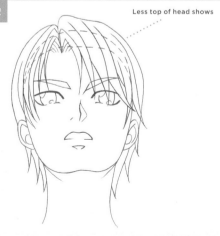

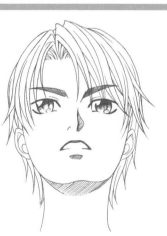

YOUR TURN!

Use this outline as the beginning of your own drawing.
Add your own guidelines and features.

THE MANGA HEAD

"DOWN" ANGLE

With boy characters, this angle creates a moody, reflective attitude. Here, the guidelines curve upward at the edges, and you see more of the top of the head and less of the mouth and chin area.

FIG 1

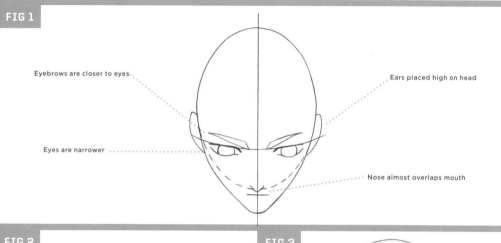

Eyebrows are closer to eyes

Ears placed high on head

Eyes are narrower

Nose almost overlaps mouth

FIG 2

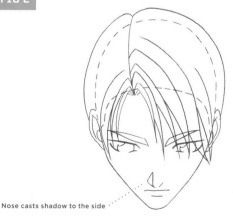

Nose casts shadow to the side

FIG 3

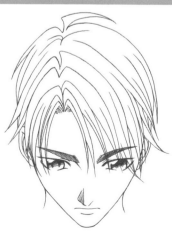

YOUR TURN!

Use this outline as the beginning of your own drawing.
Add your own guidelines and features.

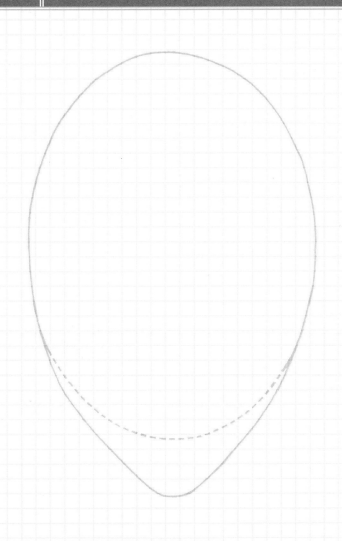

EYE BASICS

FEMALE EYES

Nothing says manga so much as the eyes. They spotlight the charisma and sheer brilliance of these popular, expressive characters. There are many ways to draw manga eyes; however, the *shoujo* style, famous for its big-eyed, youthful personalities is perhaps the most popular manga style of all, so we'll focus on *shoujo*-style eyes. They all share common traits that give them a consistently charming appearance.

• The iris in female manga eyes is larger than it is in male eyes, taking up much more of the eyeball area. As a result, the surrounding white areas are smaller. Both eyelids display eyelashes, which are more pronounced on the upper eyelid than on the lower one. The eyebrow is not too heavy.

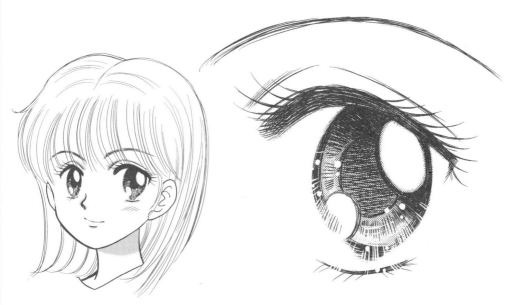

Note that there are two main eye shines, placed diagonally across from each other within the iris. The top shine is always larger. There is also a dark outline around the iris (which is an optional element) and a central dark pupil. A line above the top eyelid indicates the crease where the eyelid folds back into the eye socket when the eye is open. Eyelashes appear on upper and lower eyelids.

YOUR TURN!

Using the example above, add the eyes to these heads. You'll want to start by lightly penciling in some guidelines and then filling out the eye details.

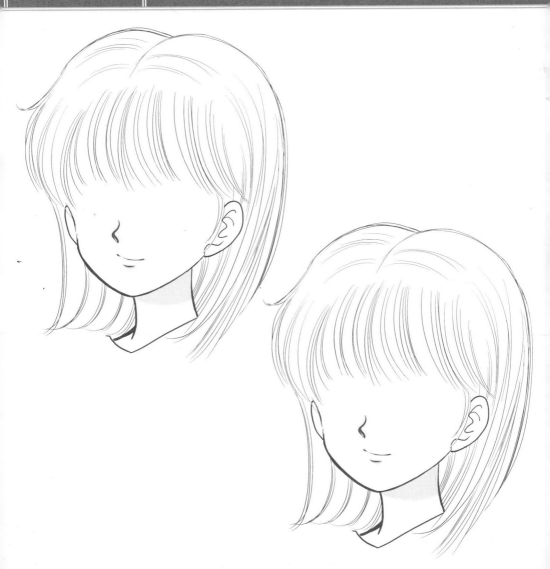

EYE BASICS

MALE EYES The iris in male manga eyes is smaller than it is in female eyes, taking up less of the eyeball area, so use a smaller oval to indicate it. There are no—or only the barest minimum of—eyelashes. The eyebrow, while still not too bushy, is thicker than the female eyebrow.

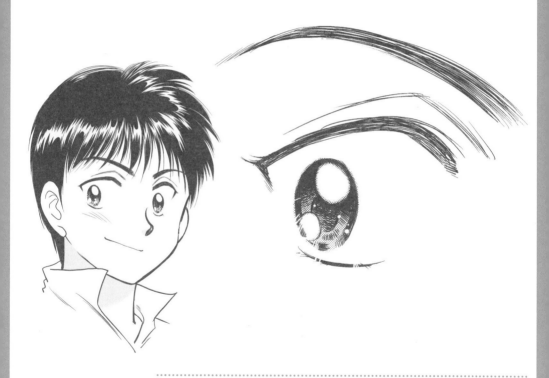

Start with ovals, not circles, for the irises. Frame the eyeball with a heavy top eyelid and a thin lower eyelid. Note that the upper eyelids arch toward the bridge of the nose, as if they're bending toward each other. • It's rare that you'll see manga eyes without some texturing inside of the iris. To texture the eye, vary the light and dark strokes of your pencil shading by applying more or less pressure.

YOUR TURN!

Using the example above, add the eyes to these heads. You'll want to start by lightly penciling in some guidelines (the eye line) and then filling out the eye details.

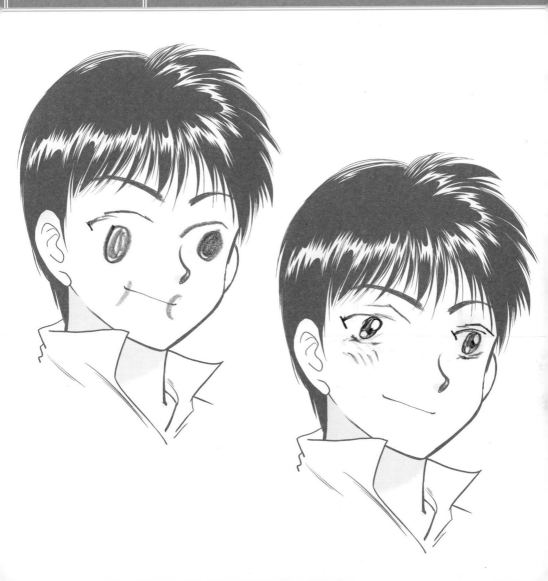

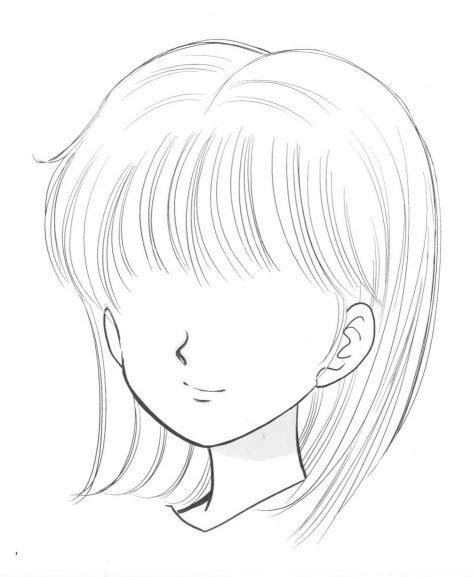

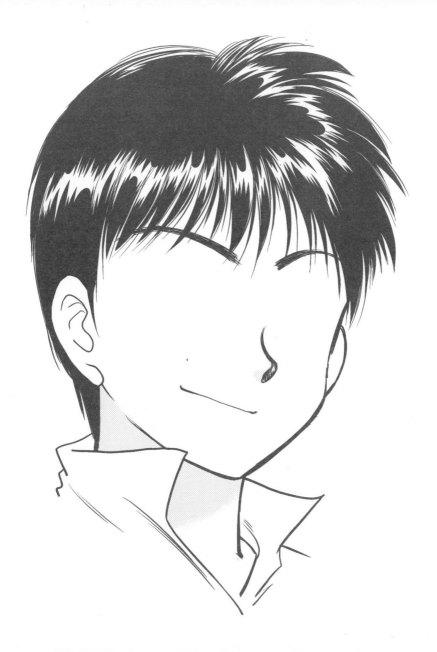

MANGA EYES

EYE STYLES

SHOUJO EYES

Here are some variations of eye types, all within the *shoujo* style. With the nose and mouth being much more subtle on manga-style characters than they are on American-style characters, the eyes become the central focus of the face.

ALMOND-SHAPED

DROOPING

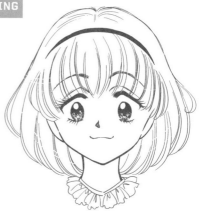

ANDROGYNOUS

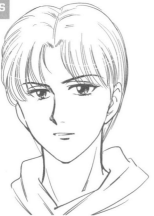

SMALL IRISES

YOUR TURN!

Using the examples, try re-creating these eye styles in the spaces provided.

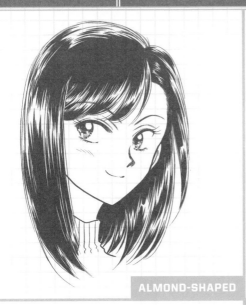

ALMOND-SHAPED

ANDROGYNOUS MALE

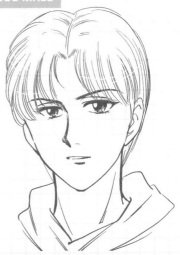

YOUR TURN!

Using the examples, try re-creating these eye styles in the spaces provided.

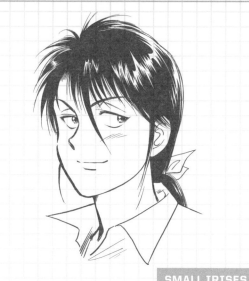

SMALL IRISES

DROOPING

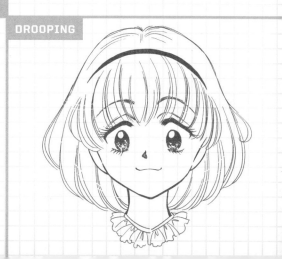

MANGA EYES

Okay, be honest. Are you guilty of trying to create an expression using only the mouth? The mouth is important, but it's often only a supporting element, while the eyes are where the emotions really catch fire. You probably already know that the eyebrows help create an expression, but don't leave out the heavy eyelids, which are just as essential in conveying attitudes. Lots of expressions depend upon how high the eyelids rise above the eyes or on whether the eyelid touches, or actually crushes down on, the eyeball. And note that the eyeball itself changes shape and size according to the expression.

HAPPY

ANGRY

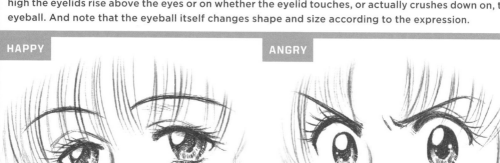

SURPRISED

SAD

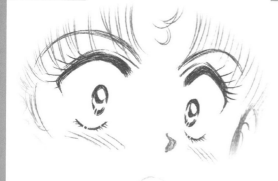

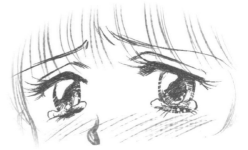

YOUR TURN!

Using the examples, try re-creating these emotions in the spaces provided.

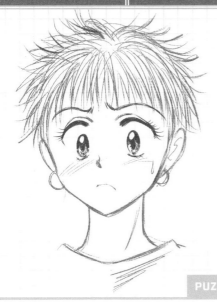

PUZZLED

WINKING

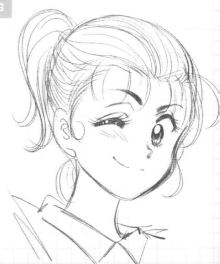

YOUR TURN!

Using the examples, try re-creating these emotions in the spaces provided.

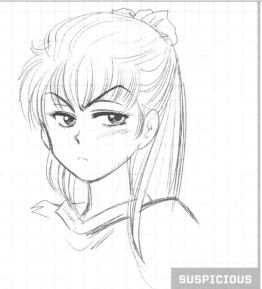

SUSPICIOUS

DREAMY

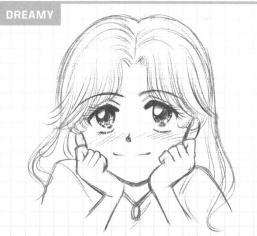

YOUR TURN!

Using the examples, try re-creating these emotions in the spaces provided.

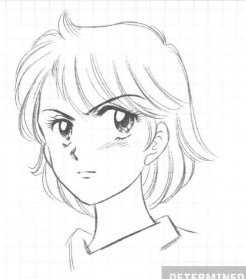

DETERMINED

FEARFUL

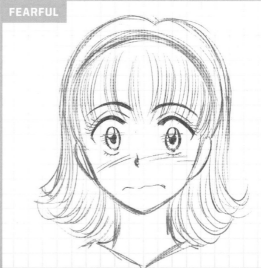

Using the examples, try re-creating these emotions in the spaces provided.

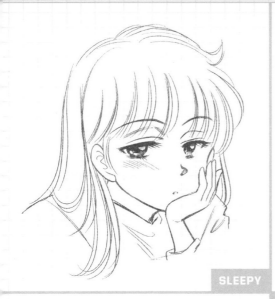

SLEEPY

TEARFUL

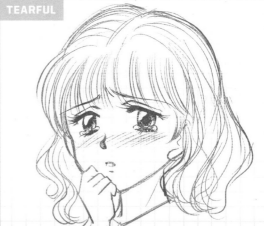

YOUR TURN!

Using the examples, try re-creating these emotions in the spaces provided.

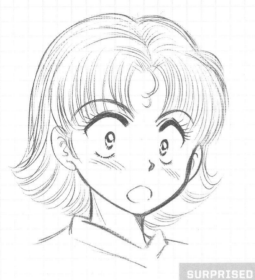

SURPRISED

ANGRY

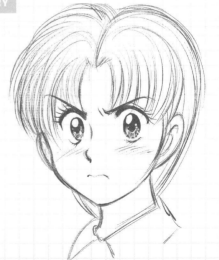

MANGA HAIR

Hair is a very important feature in manga. It's used to add glamour, to add size to the head (and thereby increase the visual presence of the character), and to carve out a unique identity for a character whose face might otherwise look similar to others. • Ponytails are common on female characters throughout manga. Buns are also very popular, especially in the magical girl genre. Long, wavy hair is popular for manga schoolgirls.

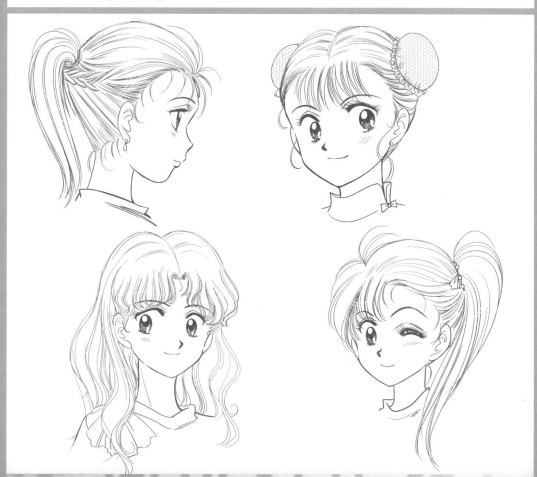

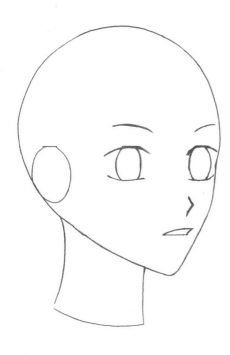

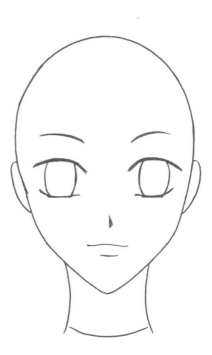

MANGA HAIR

Ponytails can be pulled to the side for a more casual look. Ringlets are mostly used on characters in historical manga genres or stories.

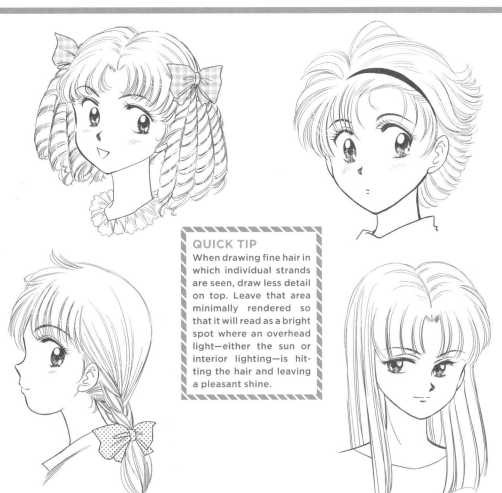

QUICK TIP

When drawing fine hair in which individual strands are seen, draw less detail on top. Leave that area minimally rendered so that it will read as a bright spot where an overhead light—either the sun or interior lighting—is hitting the hair and leaving a pleasant shine.

YOUR TURN!

Using the examples above, try adding hair to the blank heads.

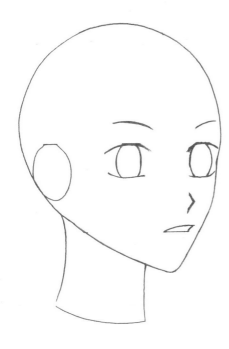

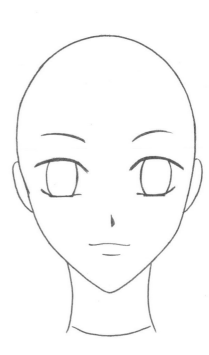

MANGA HAIR

Unless you're drawing samurai action characters or a teen-idol type with superlong hair, boys' hair-styles are much less varied than those of girls.

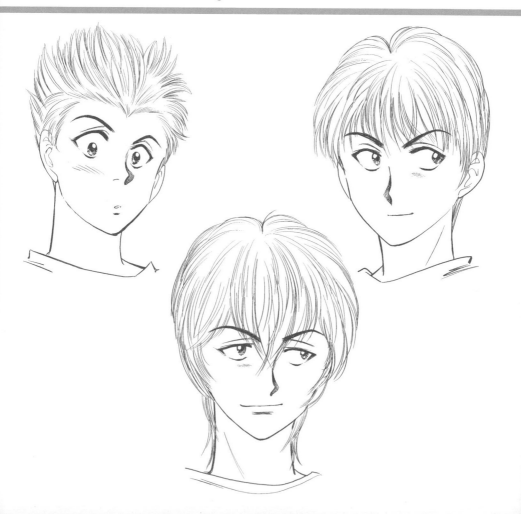

Using the examples above, try adding hair to the blank heads.

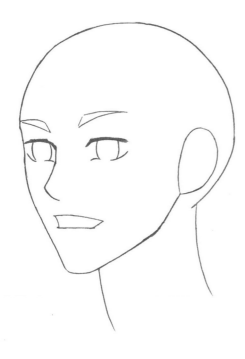

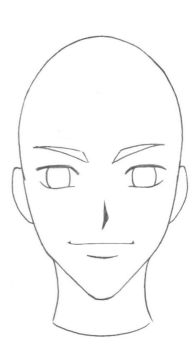

BOYS

Here are more examples of hairstyles.

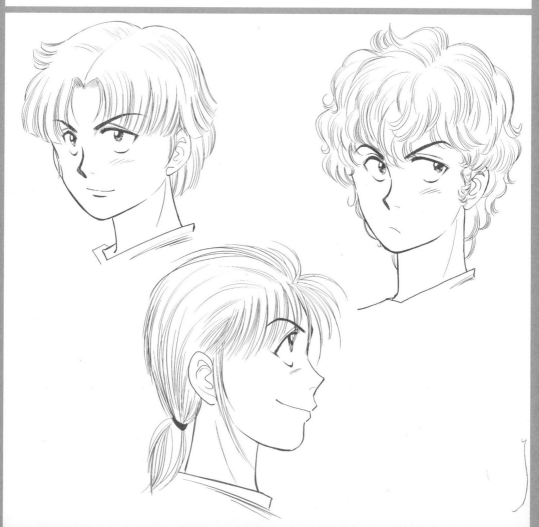

YOUR TURN!

Using the examples above, try adding hair to the blank heads.

THE MANGA BODY

FRONT VIEW Some people love to draw heads but are somewhat intimidated about tackling bodies. The truth is that many aspiring artists greatly underestimate their own abilities. Think about it. Throughout the day, you continually see people—bodies—walking past you. You notice their torsos, arms, and legs. You only need to tap into that part of your brain where images of the body are already stored. • Although an evenly balanced front view isn't the most natural-looking pose, having a character stand squarely in a front pose is the clearest way to show the entire figure.

FINAL DRAWING

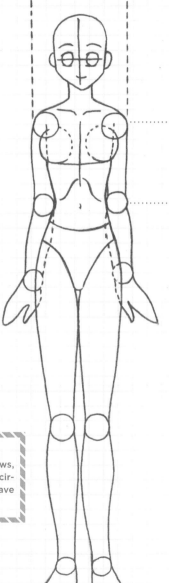

TRACE THIS!

Use this basic construction as the foundation for your drawing.

Women's shoulders and hips are the same width

The elbow joint lines up with the bottom of the rib cage—a good tip to remember for proportions!

QUICK TIP

Major joints—like the shoulders, elbows, and knees—are best represented by circles, as it reminds the artist that they have thickness.

THE MANGA BODY

SIDE VIEW

When a character is shown in a side view, the reader is not directly drawn into the action in the scene, because the angle isn't moving the figure toward or away from us. It's a good transition angle. It can work well between two more-intense shots to change the pace visually.

FIGURE 1

FINAL DRAWING

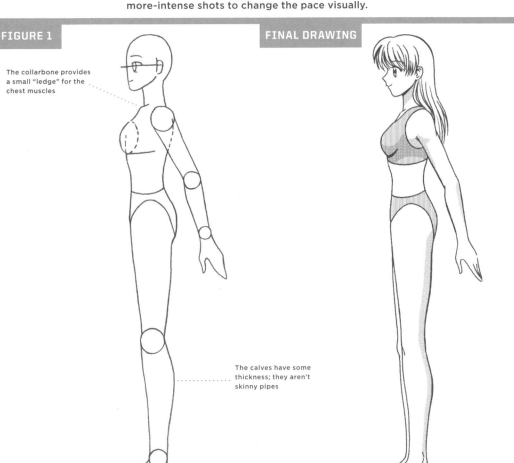

The collarbone provides a small "ledge" for the chest muscles

The calves have some thickness; they aren't skinny pipes

THE MANGA BODY

THREE-QUARTERS VIEW

The three-quarters view is a very natural-looking pose. Unlike the front view, the characters appear relaxed, even though their shoulders and hips are square.

FIGURE 1

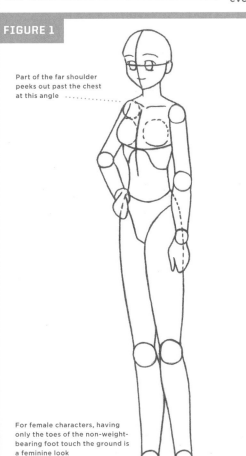

Part of the far shoulder peeks out past the chest at this angle

For female characters, having only the toes of the non-weight-bearing foot touch the ground is a feminine look

FINAL DRAWING

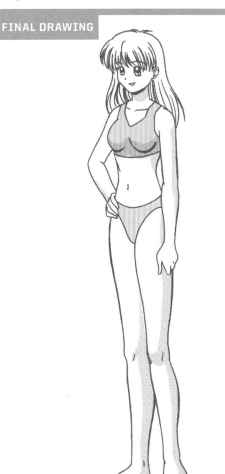

THE MANGA BODY

TEEN GIRL

THREE-QUARTERS REAR VIEW

Why would you need an angle like this? When you have two people talking to each other, one of them would most likely be posed in a three-quarters front view, facing the reader, while the other would be—you guessed it—in a three-quarters rear view, facing the first character. So it's very helpful to have this pose in your arsenal.

FIGURE 1

FINAL DRAWING

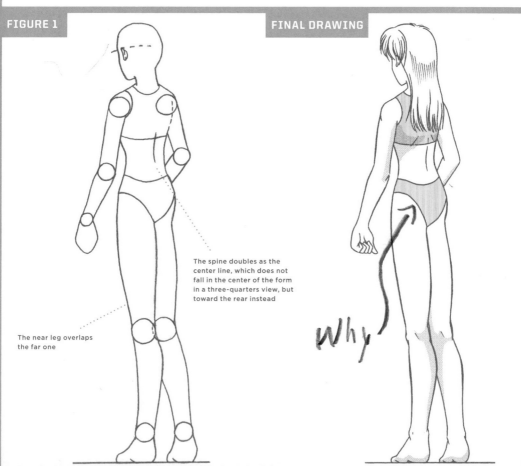

The spine doubles as the center line, which does not fall in the center of the form in a three-quarters view, but toward the rear instead

The near leg overlaps the far one

Why

THE MANGA BODY

REAR VIEW Manga is filled with dramatic moments. Characters say pithy things, then turn and walk away hauntingly. Sometimes they cry out for vengeance and run after the bad guys. Sometimes they run after their boyfriends or girlfriends. The rear view is not used as frequently as the others, but when you need it, you'll have it.

FIGURE 1

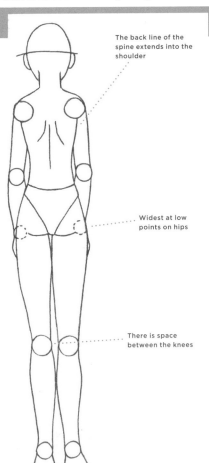

The back line of the spine extends into the shoulder

Widest at low points on hips

There is space between the knees

FINAL DRAWING

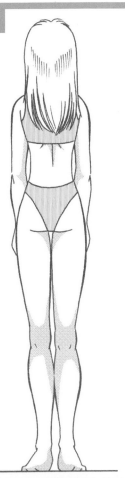

Start with a rough sketch of figure 1, and then fill in the details.

THE MANGA BODY

FRONT VIEW

Once again, the front view isn't the most natural-looking pose, because he's standing at attention, but having a character posing squarely in a front pose is the clearest way to show the entire figure.

FINAL DRAWING

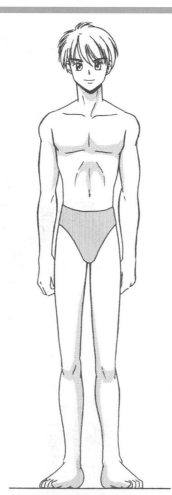

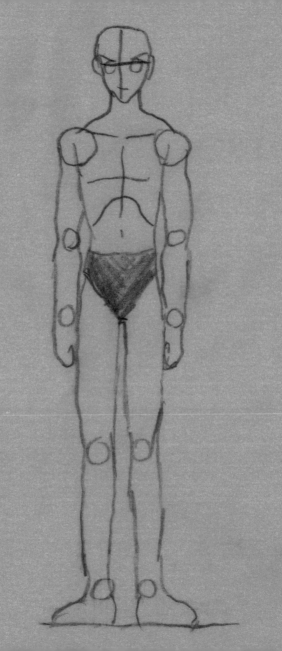

Use this basic construction as the foundation for your drawing. • Take careful note of proportions and placement.

Men's shoulders are wider than their hips

Remember that the elbow joint lines up with the bottom of the rib cage!

Hands are halfway down the upper leg

SIDE VIEW

You won't be using this view too often, but it's a good transition angle. It can work well between two more-intense shots to change the pace visually.

FIGURE 1

FINAL DRAWING

The collarbone provides a small "ledge" for the chest muscles

There's mass to the back. The line of the back doesn't continue straight down from the neck; it curves outward. Don't draw it as a straight line.

The calves have some thickness; it's a developed muscle

THE MANGA BODY

TEEN BOY

THREE-QUARTERS VIEW

As mentioned before, the three-quarters view is a natural-looking pose. It's a good idea to become very familiar with this angle. It's a pleasing look.

FIGURE 1

FINAL DRAWING

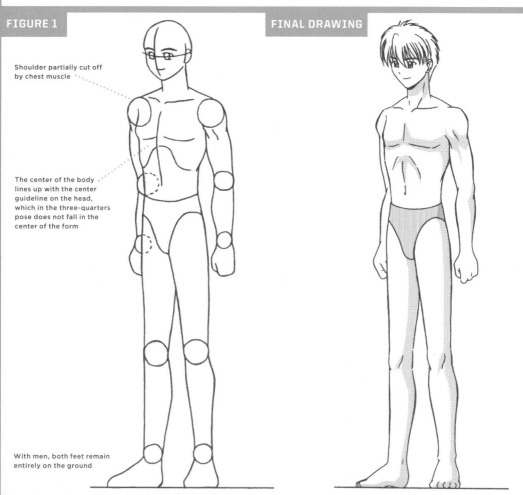

Shoulder partially cut off by chest muscle

The center of the body lines up with the center guideline on the head, which in the three-quarters pose does not fall in the center of the form

With men, both feet remain entirely on the ground

YOUR TURN!

Start with a rough sketch
of figure 1, and then fill in
the details.

THE MANGA BODY

THREE-QUARTERS REAR VIEW

As mentioned before, this is a helpful pose to have when characters are facing each other. It's a good idea to pay close attention to body language in this pose, and make sure you're getting the positioning right.

FIGURE 1

FINAL DRAWING

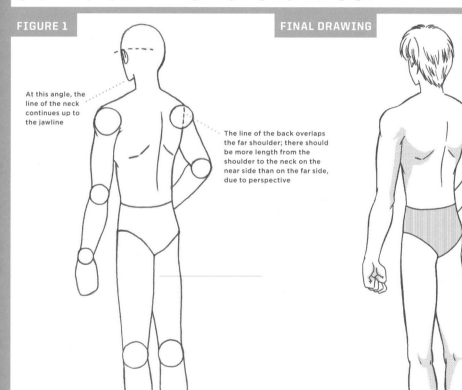

At this angle, the line of the neck continues up to the jawline

The line of the back overlaps the far shoulder; there should be more length from the shoulder to the neck on the near side than on the far side, due to perspective

YOUR TURN!

Start with a rough sketch
of figure 1, and then fill in
the details.

THE MANGA BODY

TEEN BOY

REAR VIEW This pose is not used as frequently as the others, but when you need it, you'll have it. Pay close attention to the relationship between the neck and shoulders.

FIGURE 1

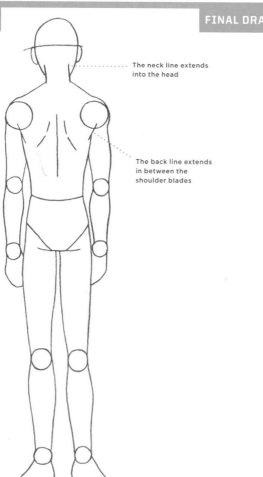

The neck line extends into the head

The back line extends in between the shoulder blades

FINAL DRAWING

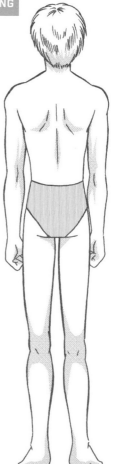

YOUR TURN!

Start with a rough sketch of figure 1, and then fill in the details.

THE MANGA BODY NATURAL STANDING POSES

MORE RELAXED

Keep in mind that standing poses are based on a few mechanics. The body reacts as if it's built out of a stack of dominoes. When a leg or hip shifts to make the stance more comfortable, the rest of the body must adjust; otherwise, the entire stack of dominoes would go out of whack and tumble to the ground. • The knees and feet are pointed outward at a slight angle, and the shoulders are also a bit relaxed. The arms are positioned more loosely around the body and slightly forward of the hips and thighs.

FIGURE 1

FINAL DRAWING

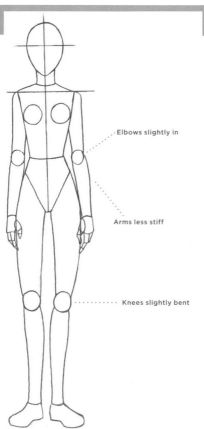

Elbows slightly in

Arms less stiff

Knees slightly bent

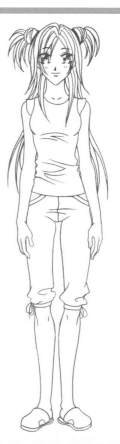

YOUR TURN!

Start with a rough sketch of figure 1, and then fill in the details.

THE MANGA BODY NATURAL STANDING POSES

MOST NATURAL Here's how the different parts of the body react to one another, like dominoes: The weight-bearing leg locks under the weight of the body. This pushes the hip up on that side of the body. To compensate, the shoulder on that side of the body dips down, forcing the opposite shoulder to rise to counterbalance. This, in turn, pushes down the hip on the opposite side of the body, which reduces the amount of space between that hip and the floor and forces that leg to move away from the body to accommodate its own length.

FIGURE 1 **FINAL DRAWING**

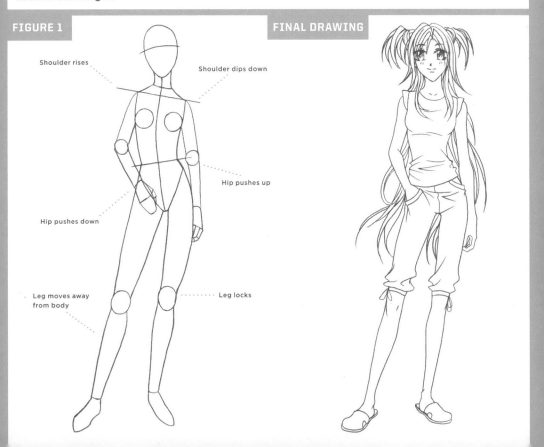

Shoulder rises

Shoulder dips down

Hip pushes up

Hip pushes down

Leg moves away from body

Leg locks

THE MANGA BODY — NATURAL STANDING POSES

ONE FOOT FARTHER AWAY FROM BODY

Similar to the Most Natural pose in the previous exercise, this variation moves the non-weight-bearing leg farther away from the weight-bearing one. This gives the pose a more stylish attitude. Note that the heel of the weight-bearing foot aligns with the pit of the neck.

FIGURE 1

FINAL DRAWING

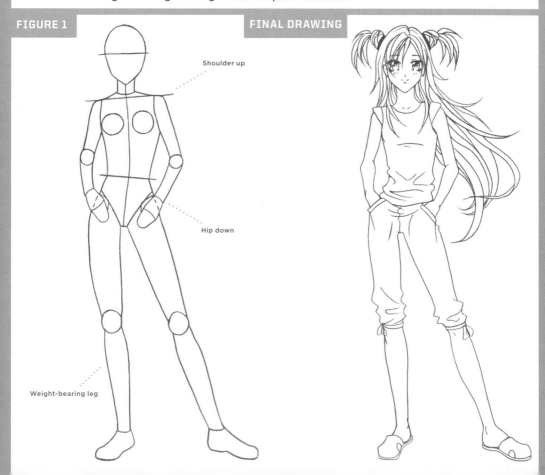

Shoulder up

Hip down

Weight-bearing leg

NATURAL STANDING POSES

ONE KNEE BENT, HANDS BEHIND BODY

In the three-quarters view, it becomes more difficult—and less necessary—to explicitly show the tilt of the shoulders and hips. But there's an easy way to prevent the pose from appearing stiff at this angle: simply highlight the in-and-out curves of the back.

FIGURE 1

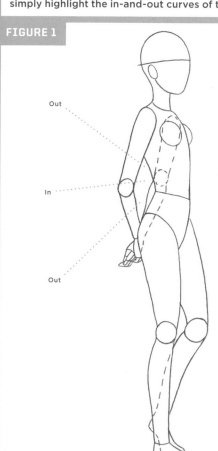

Out

In

Out

FINAL DRAWING

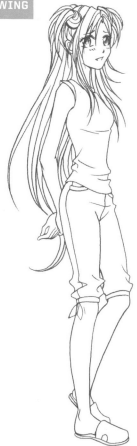

THE MANGA BODY NATURAL STANDING POSES

ONE KNEE BENT, HANDS IN FRONT OF BODY

The locked leg is always the weight-bearing one. The bent leg is the one that's relaxed. You can see the tension in the locked leg in the outwardly curved muscle of the thigh, which indicates that the leg is flexed. The balls of the foot anchor this pose. Keeping the knees together gives the figure more stability.

FIGURE 1

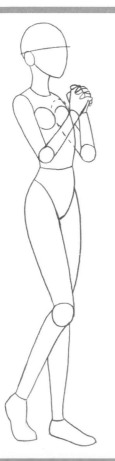

FINAL DRAWING

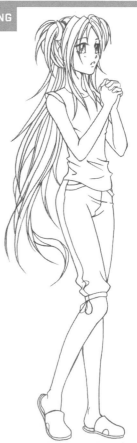

YOUR TURN!

Start with a rough sketch
of figure 1, and then fill in
the details.

HANDS

THE SKELETON

All artists, at one time or another, have wondered where the joints are on the fingers or thumbs. Let's go to the source: the skeleton. As you can see, each bone of the thumb and fingers gets shorter as you move toward the tips. Most of the palm is made up of a continuation of finger bones with a cluster of smaller bones at the base. The skeleton gives a clear overall concept of the hand, but for drawing purposes, you can start with a simplified model, sectioned into individual joints.

FRONT

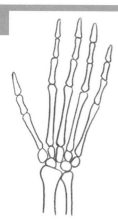 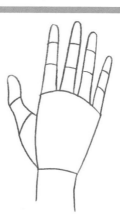 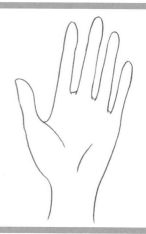

BACK

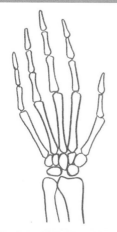 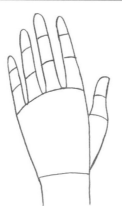

YOUR TURN!

Try drawing a hand on your own first. Using your own as a reference, practice the basic hand shape.

FEMALE HANDS

Pretty face, pretty hands. They go together. It takes a subtle touch to draw pretty hands: no hard and straight lines, no sharp points for nails, which would make them look like claws! When the fingers are bent, you have to indicate the knuckles just slightly; if you don't, they will look like noodles. But, in general, feminine hands show little in the way of knuckle definition.

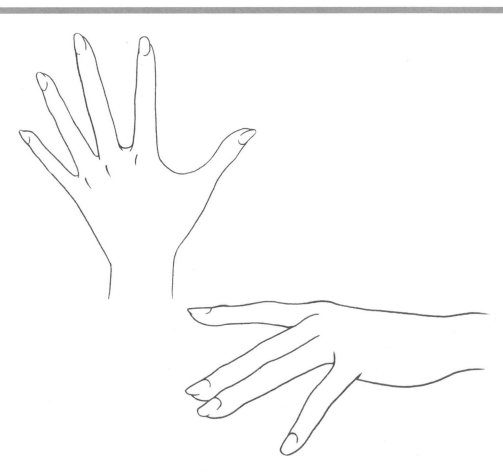

TRACE THIS!

Use these examples to get a sense of how graceful the lines are.

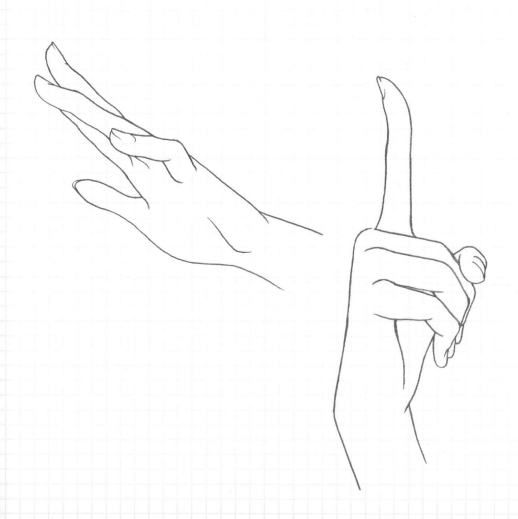

Take your time smoothing out the lines and making the nails soft.

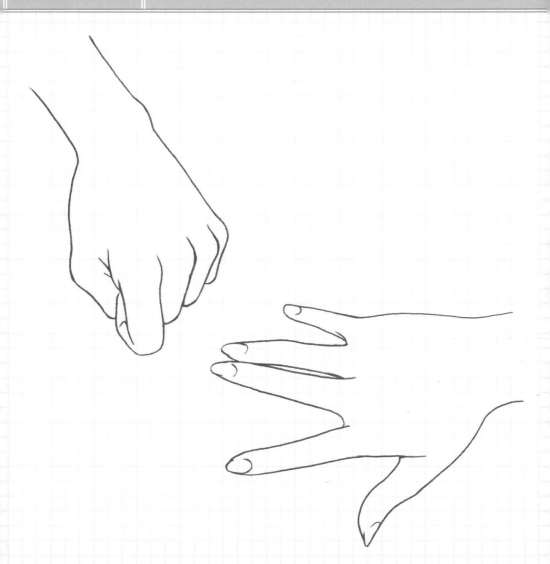

MALE HANDS

Male hands are slightly more challenging to draw than female hands, because they aren't as soft looking. To make them more rugged, you need to draw each bent joint with a harder angle. And remember this important hint: the top sides of the fingers are always flat; it's the undersides that are slightly rounded with padding.

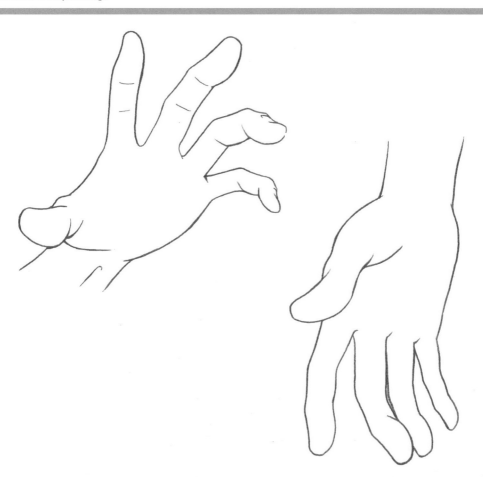

TRACE THIS!

Use these examples to get a sense of how hard the angles are.

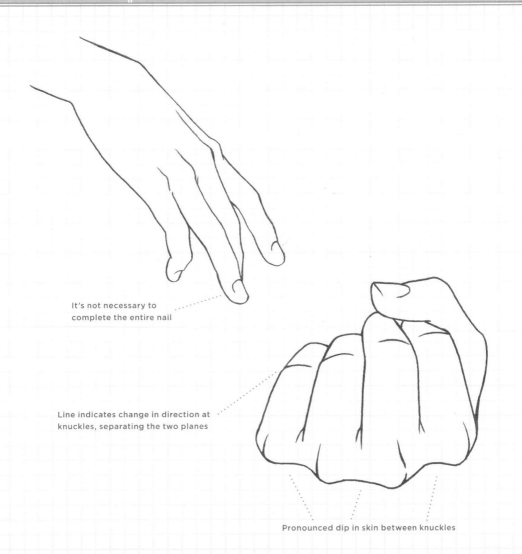

It's not necessary to complete the entire nail

Line indicates change in direction at knuckles, separating the two planes

Pronounced dip in skin between knuckles

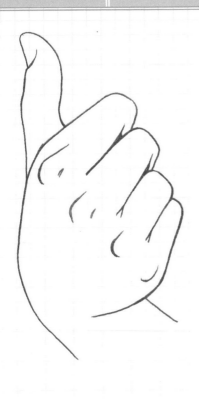

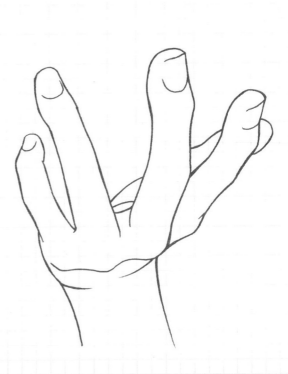

CLOTHING AND COSTUMES | SCHOOLGIRL

Let's face it, every teenage girl is looking to add a little glamour to her life. And all the popular guys—whether they want to admit it or not—are conscious of the way they look. • An enormous number of manga stories are set in Japanese high schools, where specific styles of cool Japanese school uniforms are the norm for girls. So let's familiarize ourselves with the look of the popular school uniforms.

TRADITIONAL

All buttoned up in a jacket and pleated skirt that falls to just above the knees.

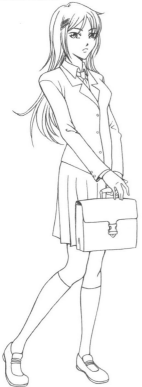

CASUAL

Short-sleeved shirt, with a slightly shorter pleated skirt and long leggings. The shoes are more playful, and instead of a tie, a ribbon is tied around the collar.

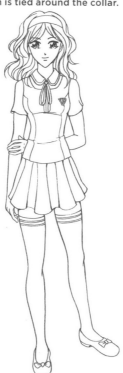

SPORTY

A loose, carefree shirt cut off just above the waistline, with leggings that go up to just below the knees and loosely laced-up shoes.

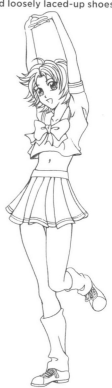

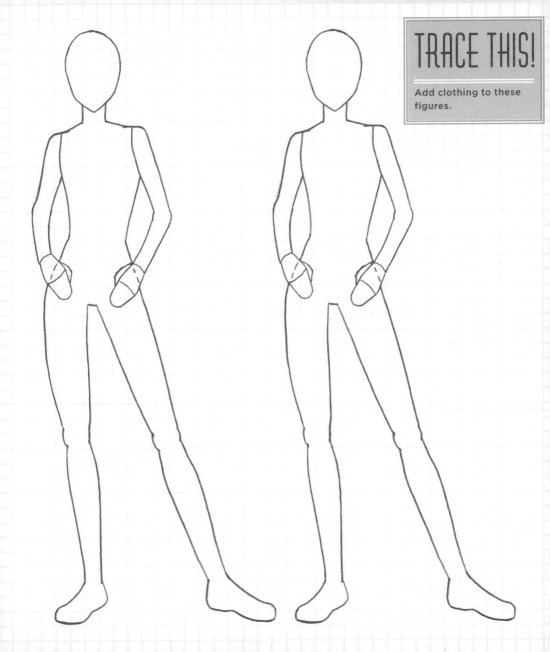

CLOTHING AND COSTUMES | SCHOOLBOY

The popular boys and girls of manga have expensive taste, but the good thing is this: it doesn't cost any more to draw an obscenely expensive Italian outfit than a pair of polyester pants. • Most teenage boys are sort of . . . um . . . slovenly. But there are exceptions. Every school has a few guys all the girls have crushes on. And all the other characters are jealous of these guys. These lady-killers are always tall and thin, and their outfits are sharp and formfitting. These guys look like they just fell out of a men's fashion magazine. These guys are called *bishanen*.

FORMAL/ELEGANT

A classic double-breasted jacket, with a buttoned-up shirt and tie.

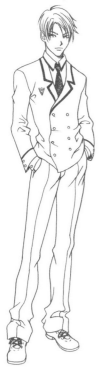

BAD-BOY CHIC

Make his outfit dark and a bit racy for school. He wears a crewneck shirt and sneakers.

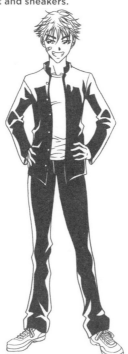

PREPPY

An open jacket and a vest over a shirt and tie. Collegiate, simple, and straightforward.

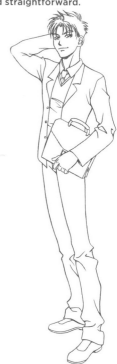

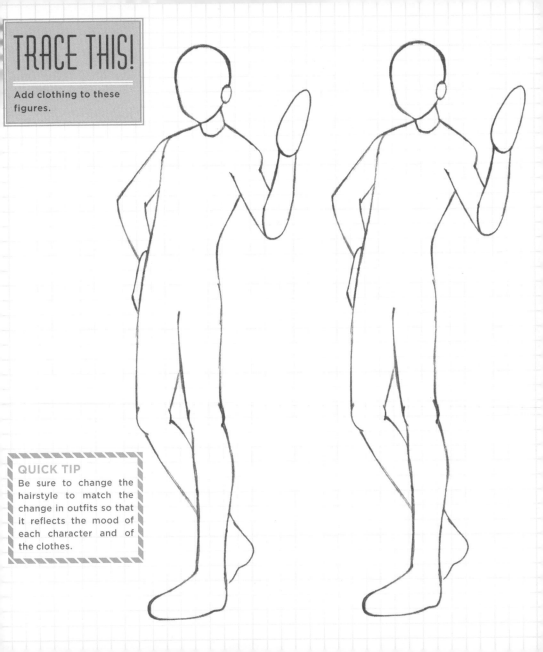

TRACE THIS!

Add clothing to these figures.

QUICK TIP

Be sure to change the hairstyle to match the change in outfits so that it reflects the mood of each character and of the clothes.

CLOTHING AND COSTUMES

Outside of school, the uniforms come off and the trendy clothes go on. Remember, Tokyo is one of the major fashion cities of the world, along with New York, London, Paris, and Rome. When the outfits are stylish enough to look like they came straight off the runways, the characters wearing them should be either older teens or, more likely, twentysomethings, called *bishoujo.*

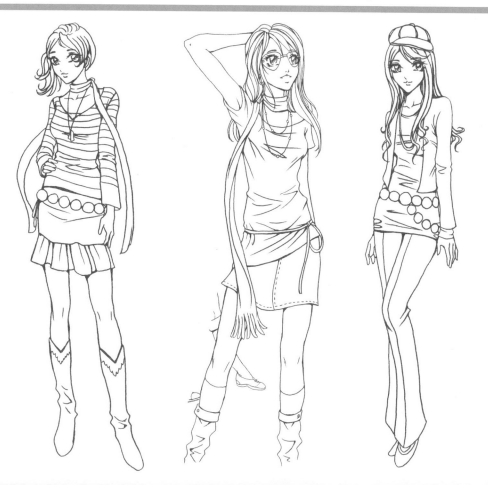

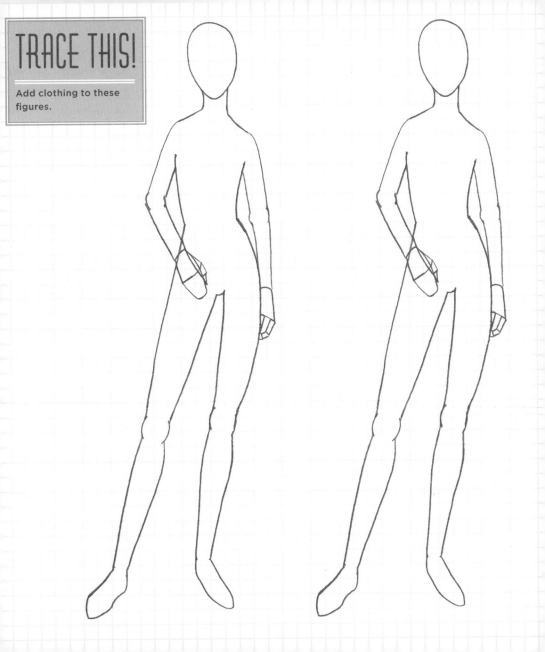

TRACE THIS!

Add clothing to these figures.

CLOTHING AND COSTUMES MAGICAL GIRLS

One of the more popular genres in manga is a subgenre of *shoujo* (girls' manga) called magical girls. Magical girls are ordinary schoolgirls who, usually by accident, discover that they can transform into superempowered, idealized versions of themselves. You can get very creative in designing these. Keep in mind that the long, flowing, fanciful hair is an integral part of the magical girl look.

CLASSIC

Decorative ornaments frequently used in hair and flowing ribbons are a popular motif.

BARE SHOULDERS

Notice her giant, swirling hair and sci-fi or fantasy-style boots.

LONG SLEEVES

These corkscrew curls are a popular effect.

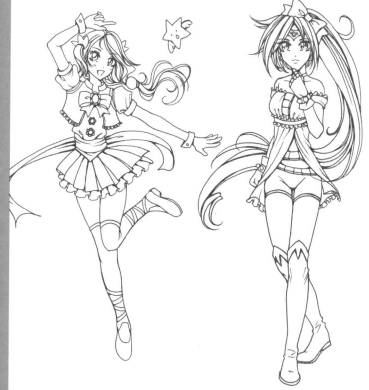

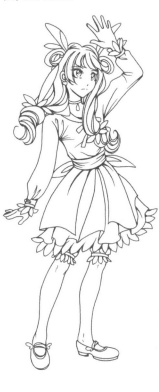

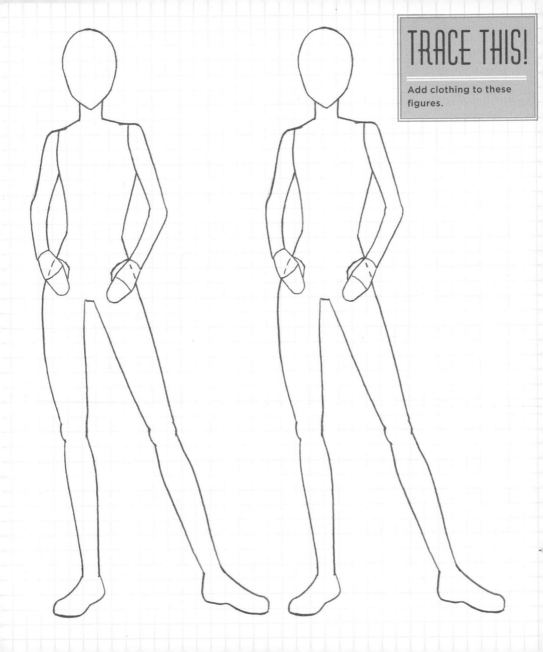

TRACE THIS!

Add clothing to these figures.

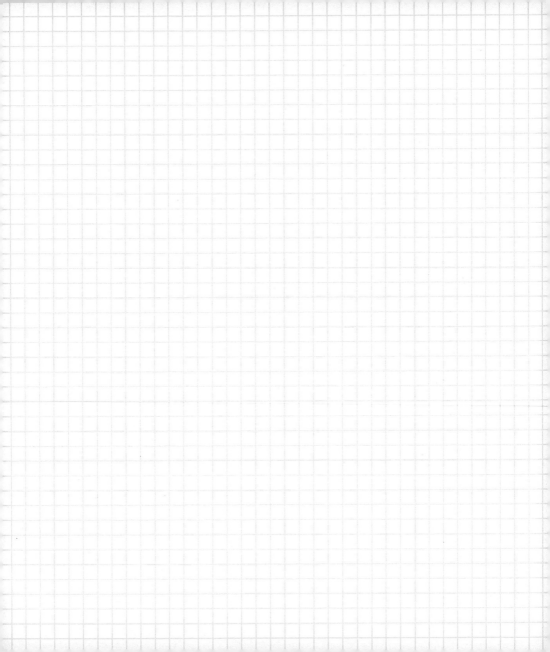

CREATING CHARACTERS | TEEN FIGHTER GIRL

She's a very popular character—pretty, youthful, and earnest, and she can knock the daylights out of the bad guys! Because she's a teen, she should have that classic big-eye manga style. This also gives her a look of integrity. Note that her hair has lots of movement, reflecting her nonstop action pose.
• Use the basic skeleton below to flesh out the figure. You want to begin by building the basic body construction (figure 1), and then start adding on the details (figure 2).

FIG 1: BASIC BODY CONSTRUCTION

The basic body construction is the time to establish the basic framework. Focus on the outline; on long, unbroken lines; and on large shapes. Don't be afraid to allow one shape to overlap another, as in the torso and the hips here. This is the time to work out any foreshortening.

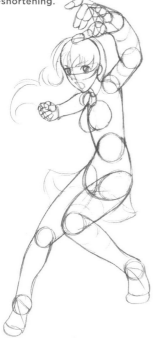

FIG 2: TIGHT PENCIL

Now you can go in and "detail out" the basic body construction you established in the previous step. Design the costume and articulate the hairstyle at this stage.

BUILD YOUR CHARACTER

The majority of artists actually begin their sketches with something that looks like figure 1, but this simplified skeleton is a great reference step. It clearly shows the position of the rib cage and of other bones.

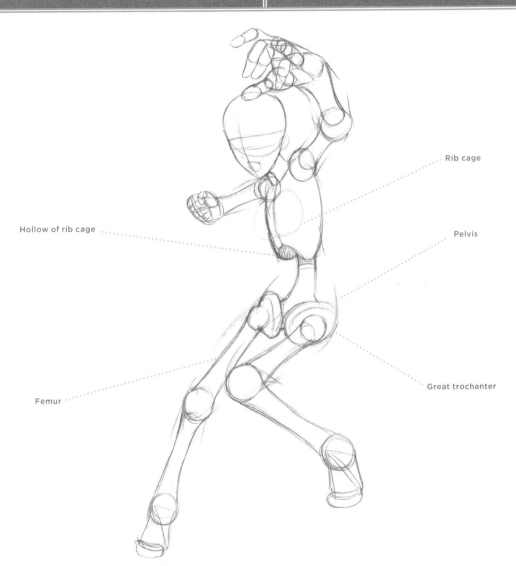

Rib cage

Hollow of rib cage

Pelvis

Femur

Great trochanter

CREATING CHARACTERS | CLASSIC TEEN HERO

You see this superpopular character everywhere. He's intense and never gives up, no matter how much danger stands in his way. Oh sure, he takes his share of hits, but he's resilient and keeps coming back. Clean-cut, nice looking, and trustworthy, you wouldn't mind if he dated your sister. Well, almost. He is, after all, still a boy. • Use the basic skeleton below to flesh out the figure. You want to begin with building the basic body construction (figure 1), and then start adding on the details (figure 2).

FIG 1: BASIC BODY CONSTRUCTION

As you flesh out the figure, indicate the effects of perspective, enlarging those parts of the body that come toward you and reducing those that recede.

FIG 2: TIGHT PENCIL

Arm guards, as well as knee and shin guards, give an ordinary school character a sci-fi flair.

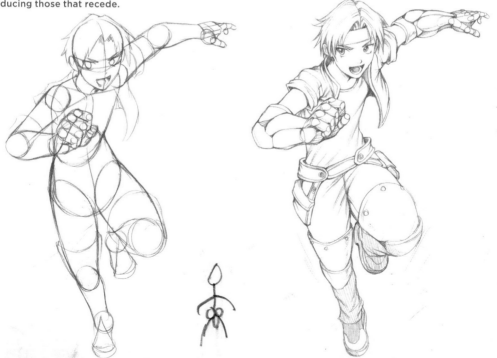

BUILD YOUR CHARACTER

One arm and the leg on the opposite side of the body come forward, and the other opposing arm and leg move back. Most of the raised lower leg is hidden under the knee. The far shoulder is partially hidden.

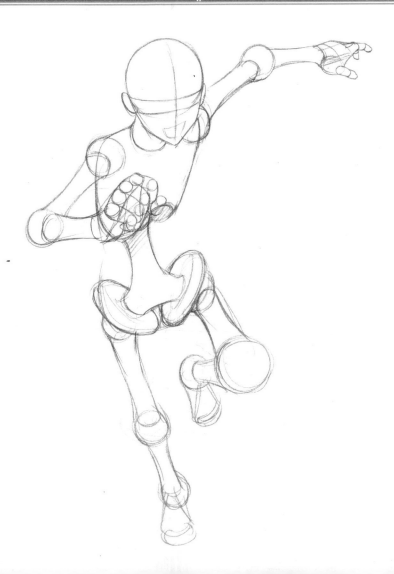

CREATING CHARACTERS | FANTASY FIGHTER

Not a magical girl type, this fantasy fighter is more mature; she's in her upper teens or early twenties. She's not a pretty little girl with the big eyes, but a *bishoujo*—a beautiful girl, and one who is also strong. • Use the basic skeleton below to flesh out the figure. You want to begin by building the basic body construction (figure 1), and then start adding on the details (figure 2).

FIG 1: BASIC BODY CONSTRUCTION

Lightly sketch in the back arm to help you get the correct placement for the far fist.

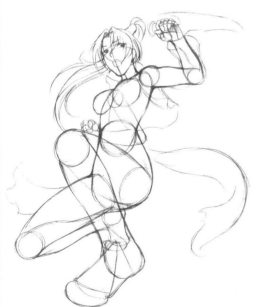

FIG 2: TIGHT PENCIL

If she's a fantasy character, her blade is going to require a bit of special treatment and finesse. It can't look like a kitchen knife used for carving the Thanksgiving turkey. Add a cool handle and a few extra planes on the blade to make it a fantasy weapon.

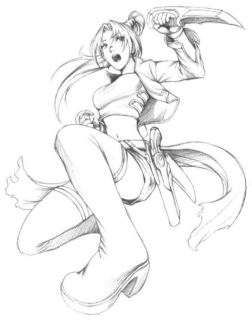

In a pose like this, where so much of the legs and hips are hidden from view and being overlapped by other parts of the body, it helps to refer to the simplified skeleton to clearly see how everything is connected.

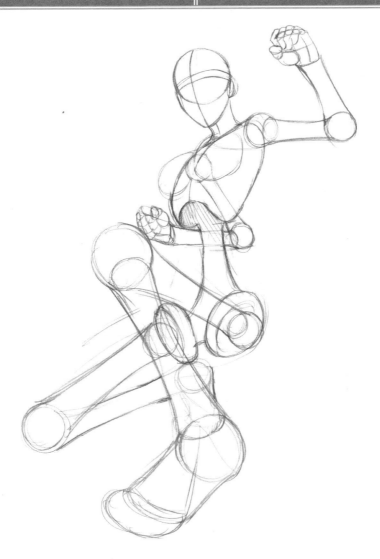

OTHER MANGA TITLES BY
CHRISTOPHER HART

Manga for the Beginner 978-0-8230-3083-5

Manga for the Beginner: Chibis 978-0-8230-1488-0

Manga Mania 978-0-8230-3035-4

Manga Mania Bishoujo 978-0-8230-2975-4

Manga Mania Chibi and Furry Characters 978-0-8230-2977-8

Manga Mania Shoujo 978-0-8230-2973-0

Manga Mania Villains 978-0-8230-2971-6

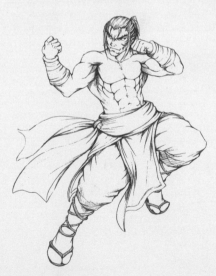